VINCENT
VAN GOGH

Creative
Inspiration

10 9 8 7 6

First published in 2017 by September Publishing

Text design by Studio April

Printed in Poland by L&C Printing Group

ISBN 978-1-910463-57-4

September Publishing
www.septemberpublishing.org

CONTENTS

Note from the Editor

As I read Vincent van Gogh's letters –
usually in quiet afternoon stretches – it was
easy to forget my task of selecting lines for
this book. Instead, I read them perhaps
a little too slowly, one by one, becoming
deeply invested in the daily thoughts,
struggles and ideas of this artist-in-process.
Somehow, he so deftly illuminated many
of my own ruminations all these decades
later: how to have patience in one's
work, how to face the daily challenge of
uncertainty, how to learn and grow through
persistent practice, among others. I came
to understand – as so many before me have
– the depth of Van Gogh's brilliance and
passion through his words. It is my hope
that the lines selected for this collection
offer you a window into his world – one
full of remarkable vision, conviction
and hope.

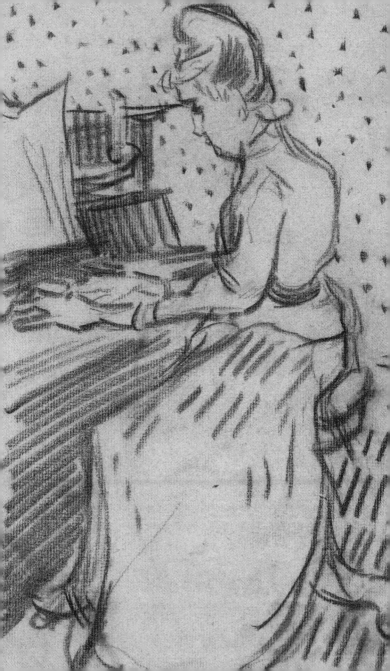

Each quote was selected from Van Gogh's letters, which are curated and translated from Dutch and French to English by the Van Gogh Letters Project. The collection contains all Van Gogh's surviving correspondence – 1,750 letters written and received between 1853 and 1890. The majority were written by Vincent to his beloved brother, Theo. And thanks to Theo, 'the great collector in the family', they have survived.

The images chosen to accompany Van Gogh's words were selected from the collection of the artist's sketches at the Van Gogh Museum. Each pencil mark is testimony to Van Gogh's commitment to practice – reminders that we shouldn't fear the blank page. We must begin, forever breaking the spell of 'I can't'.

Kelly Shetron

WHY CREATE?

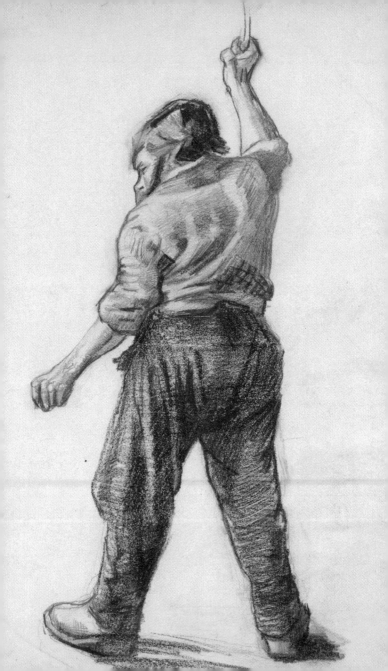

'... I'm an artist ... those words naturally imply always seeking without ever fully finding. It's the exact opposite of saying, "I know it already, I've already found it". To the best of my knowledge, those words mean "I seek, I pursue, my heart is in it".'

CREATIVE INSPIRATION
VAN GOGH

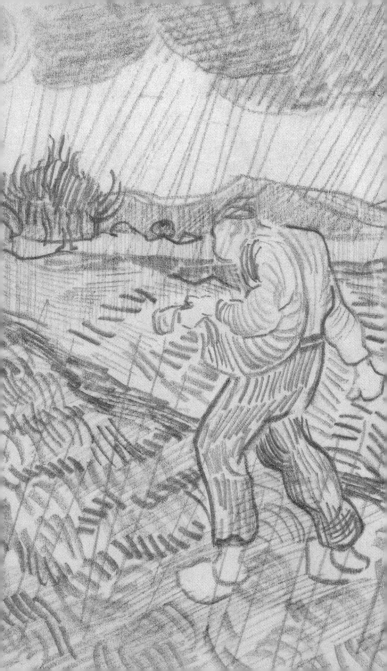

'I know no better definition of the word Art than this, "Art is man added to nature", nature, reality, truth, but with a meaning, with an interpretation, with a character that the artist brings out and to which he gives expression, which he sets free, which he unravels, releases, elucidates.'

CREATIVE INSPIRATION
VAN GOGH

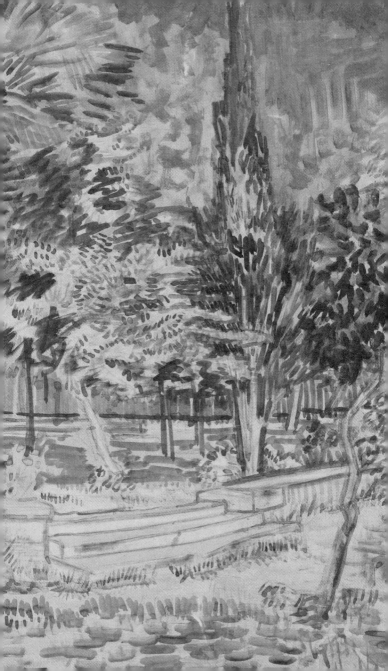

'Painting is just as good a profession by which to earn a living as, for example, smith or doctor. An artist, in any case, is the exact opposite of someone living a life of leisure, and as I said, if one wants to draw a parallel, then either a smith or a doctor corresponds more closely.'

CREATIVE INSPIRATION
VAN GOGH

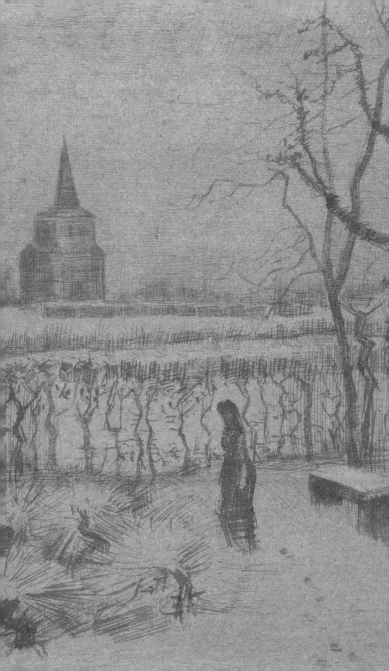

'Anyway, it's not a bad idea for you to want to become an artist, because if one has fire in one, and soul, one can't keep stifling them and – one would rather burn than suffocate. What's inside must get out.'

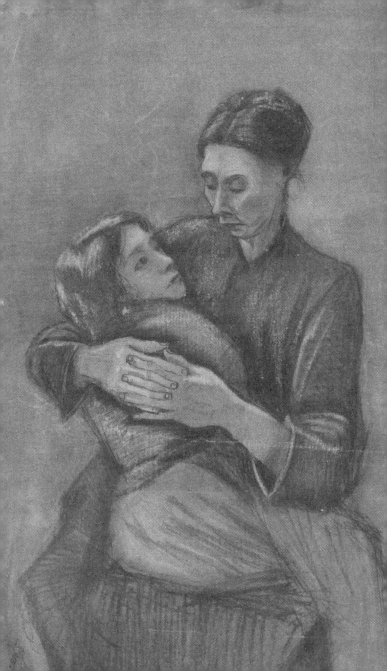

'I'd rather have 150 francs a month as a painter than 1,500 francs a month as anything else, even as an art dealer.'

CREATIVE INSPIRATION
VAN GOGH

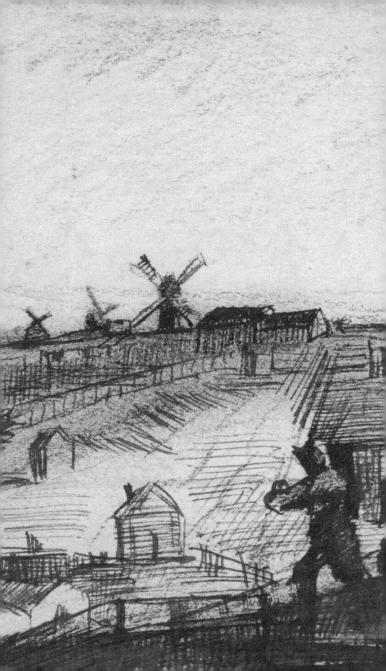

'I believe in the absolute necessity of a new art of colour, of drawing and – of the artistic life. And if we work in that faith, it seems to me that there's a chance that our hopes won't be in vain.'

CREATIVE INSPIRATION
VAN GOGH

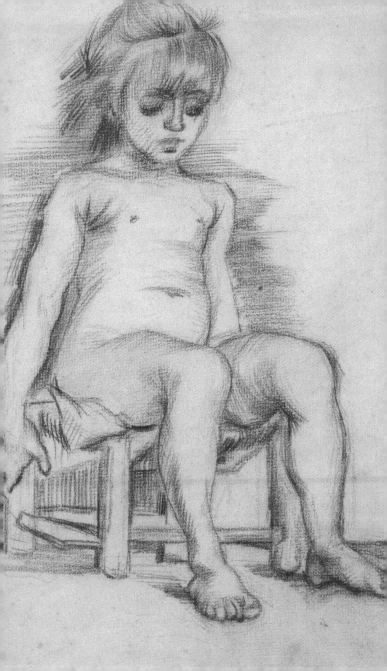

'... we're working at an art, at matters that won't be of our times only but which may also be continued by others after us.'

CREATIVE INSPIRATION
VAN GOGH

DAILY WORK

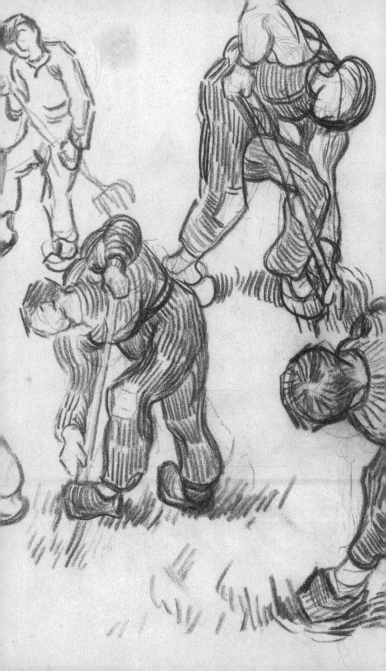

'This morning I still have a lot of work to do, I see that it isn't easy and will no doubt become much more difficult, yet have unfaltering hope that I'll succeed, and I'm also convinced that I'll learn to work by working, and that my work will become better and more substantial.'

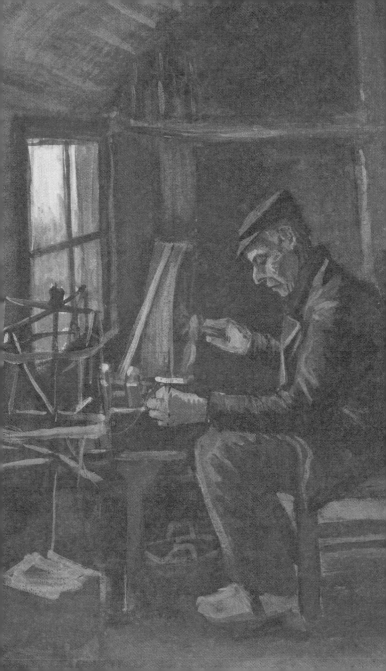

'Not doing anything else and devoting
all one's time to the work, that's still
preferable in my view. It's as if there's
something fatal in holding other positions
– perhaps it's precisely the worries,
precisely the dark side of the artistic life,
that's the best part of it. It's risky to say
this, and there are moments when one
talks differently – many go under because
of the worry – but those who struggle
through benefit later.'

CREATIVE INSPIRATION
VAN GOGH

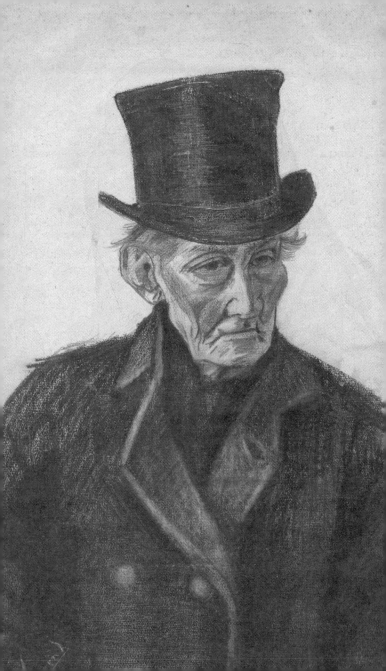

'Through working hard, old chap,
I hope to make something good one day.
I haven't got it yet, but I'm hunting it and
fighting for it, I want something serious,
something fresh – something with soul
in it! Onward, onward.'

CREATIVE INSPIRATION
VAN GOGH

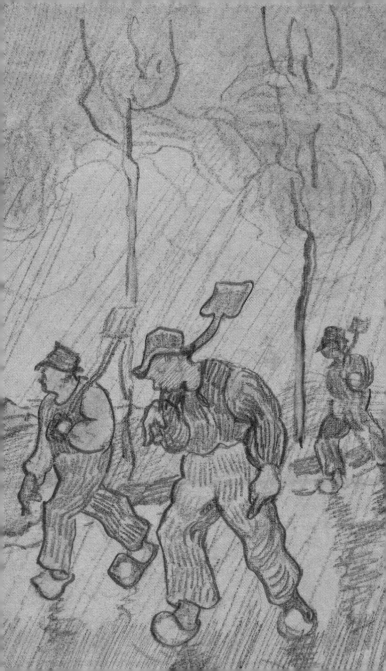

'The daily work is a thing that doesn't change, and becoming absorbed in that isn't as dangerous as looking into the unfathomable.'

CREATIVE INSPIRATION
VAN GOGH

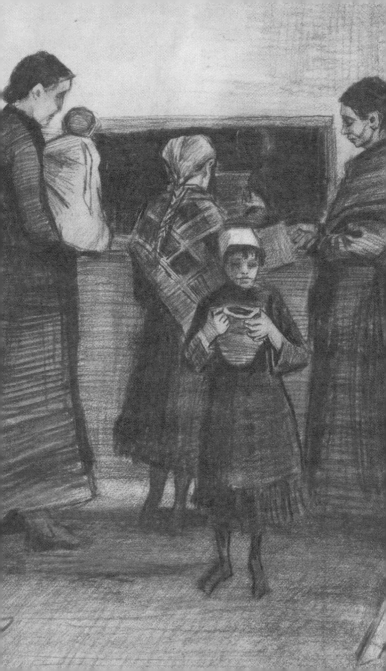

'… it seems to me more and more that the most practical and direct way to make progress with the work is not to look too far away and to stay down to earth.'

/

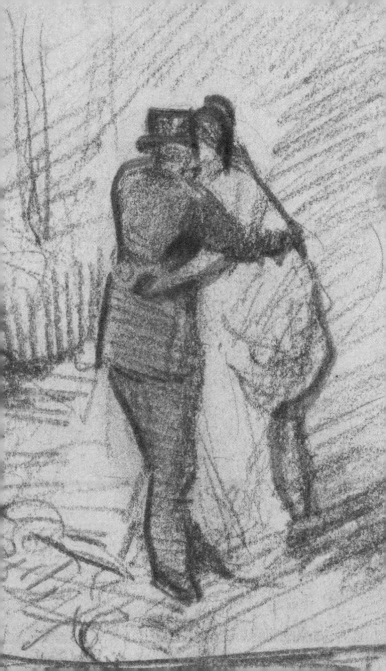

'After all, working has the secret of being able to give someone a second youth.'

'… we have in common a liking for seeing behind the scenes or, in other words, are inclined to analyze things. Now this, I believe, is exactly the quality one must have in order to paint … It may be that there has to be something innate in us, to some extent … but above all, above all, it's only later that the artistic sense develops and ripens through working.'

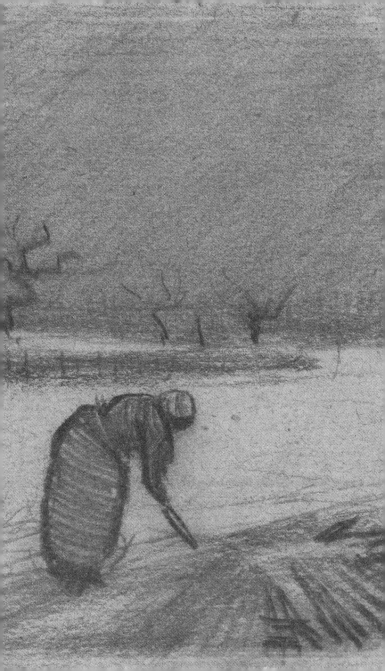

'Isn't it the emotion, the sincerity of our feeling for nature, that leads us and – if these emotions are sometimes so strong that we work – without feeling that we're working – when sometimes the brushstrokes come in a sequence and in relation one to another like the words in a speech or a letter – then we have to remember that it hasn't always been like that, and that in the future there will also be quite a few heavy days without inspiration. So we have to strike while the iron's hot and lay aside the bars we forge.'

CREATIVE INSPIRATION
VAN GOGH

PROCESS

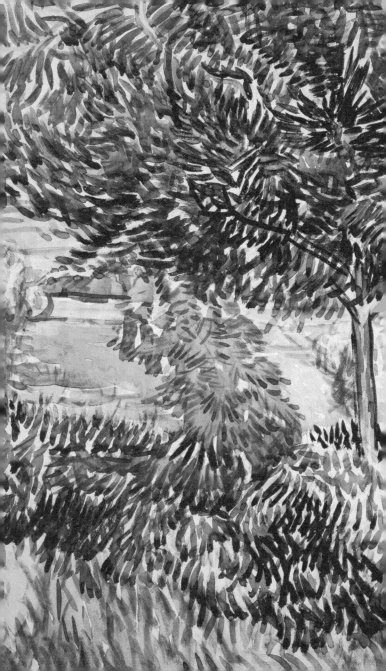

'One becomes a painter by painting.'

CREATIVE INSPIRATION
VAN GOGH

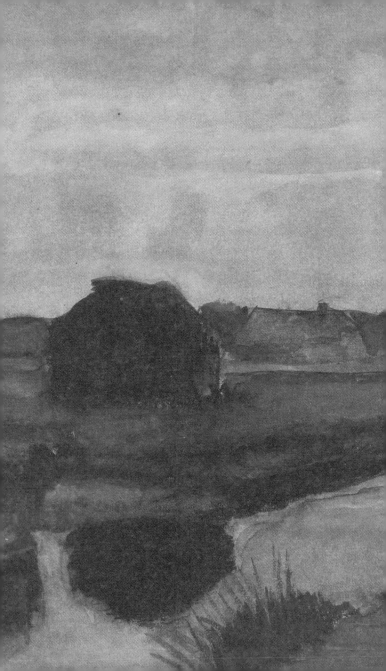

'Do you get up early? I do regularly, it's good to make a habit of it. It's precious and already very dear to me, that early morning twilight.'

CREATIVE INSPIRATION
VAN GOGH

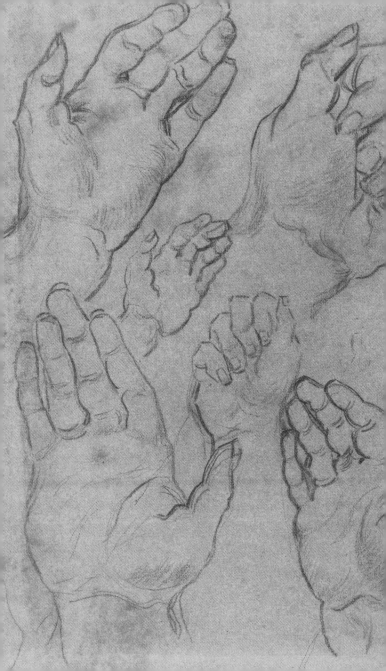

'With CONSIDERABLE practice and with *lengthy* practice, it enables one to draw at lightning speed and, once the lines are fixed, to *paint* at lightning speed.'

CREATIVE INSPIRATION
VAN GOGH

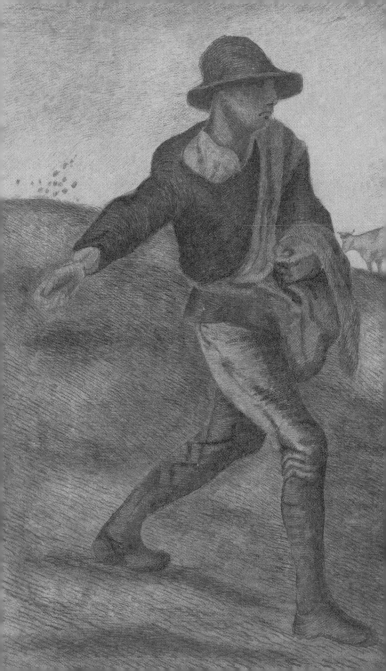

'I've been here for a few days and it's beautiful outdoors, but the weather doesn't yet permit of drawing outdoors every day.

'Meanwhile I've started on the Millets, The sower is finished and the 4 times of the day sketched. And now still to come are The labours of the field.'

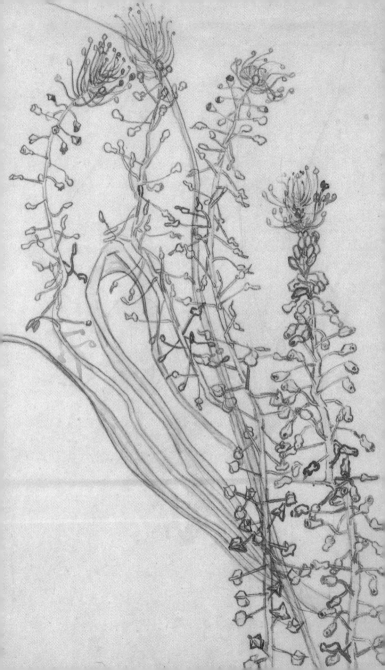

'Last year I painted almost nothing but flowers to accustom myself to a colour other than grey, that's to say pink, soft or bright green, light blue, violet, yellow, orange, fine red. And when I painted landscape in Asnières this summer I saw more colour in it than before. I'm studying this now in portraits.'

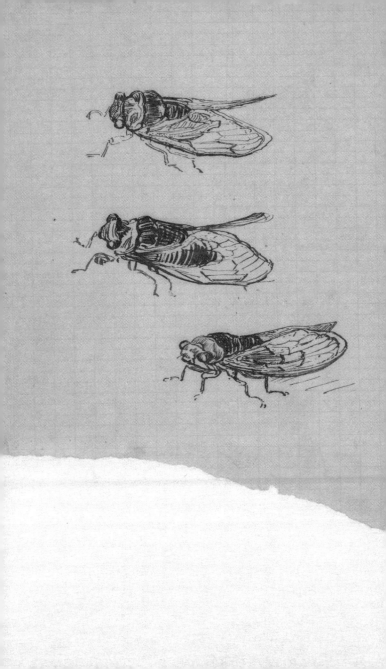

'... I've tried from the outset to maintain a certain order in my work, set a sort of rule for myself, not to be a slave to that rule but because it helps one to think more clearly.'

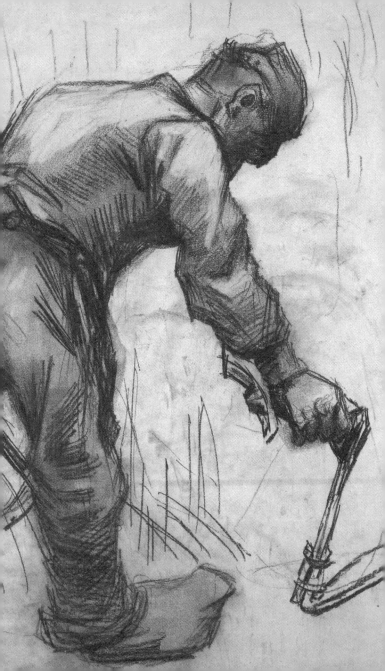

'It's always very tempting to draw a figure at rest – expressing action is very difficult, and in the eyes of many the effect is "more pleasing" than anything else.

'But this pleasing aspect mustn't lose sight of truth, and the truth is that there's more toil than rest in life.'

CREATIVE INSPIRATION
VAN GOGH

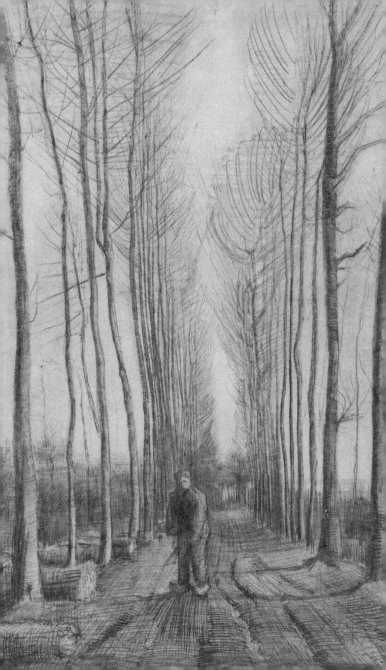

'You don't know how *paralyzing* it is, that stare from a blank canvas that says to the painter *you can't do anything*. The canvas has an *idiotic* stare, and mesmerizes some painters so that they turn into idiots themselves.

'Many painters *are afraid* of the blank *canvas*, but the blank canvas IS AFRAID of the truly passionate painter who dares — and who has once broken the spell of "you can't".'

CREATIVE INSPIRATION
VAN GOGH

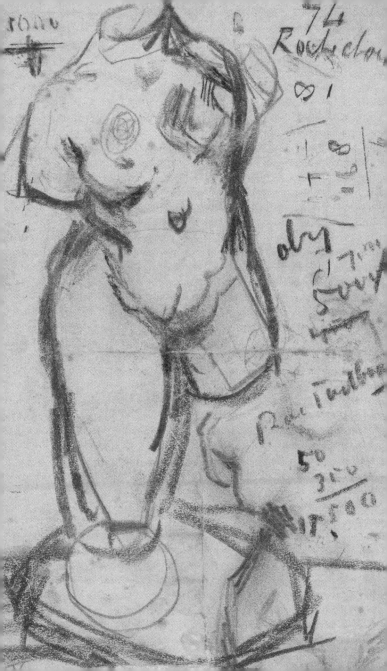

'In the studies, too, one sees for oneself the agitation and a certain precision that's diametrically opposed to the calm breadth one seeks – and yet one feels bad if one works specifically for that breadth and devotes oneself to that.

'As a result there's sometimes a bottling up of nervous restlessness and stress, and one feels an oppressiveness as on some summer days before a storm. I've just had that again, and when I feel like that I change to different work, precisely in order to start from scratch.'

CREATIVE INSPIRATION
VAN GOGH

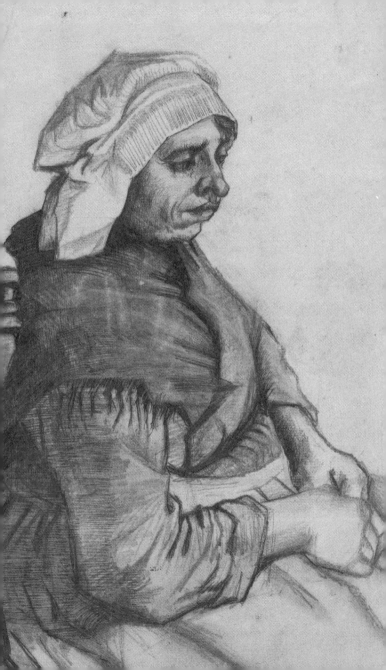

'I did the first two figures that I painted this year just the same way as I tried last year – drawing first and then filling in the outline. That's what I would call the dry manner. In the other manner one in fact does the drawing last and begins work by first seeking the tones without worrying much about it, about the drawing, just trying to put the tones roughly in their place in one go and to gradually define the form and the subdivision of the colours. Then one gets more of that effect of the figure coming out as if it's surrounded by air, and it takes on a softer quality. While the colours become more delicate, because one goes over them often and sweeps one colour through another.'

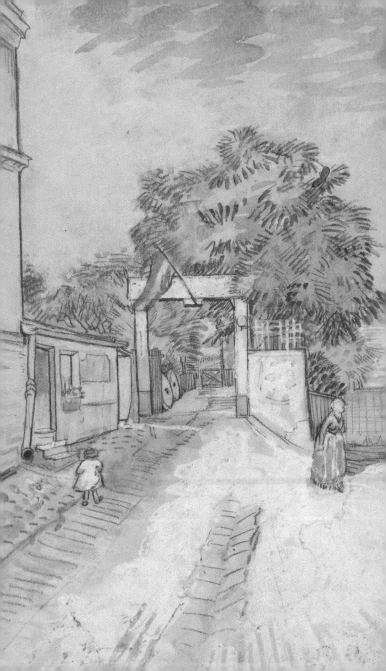

'And the fact that I want to paint a great deal is precisely because I *very much* want to have something constant and systematic in my brushwork …'

CREATIVE INSPIRATION
VAN GOGH

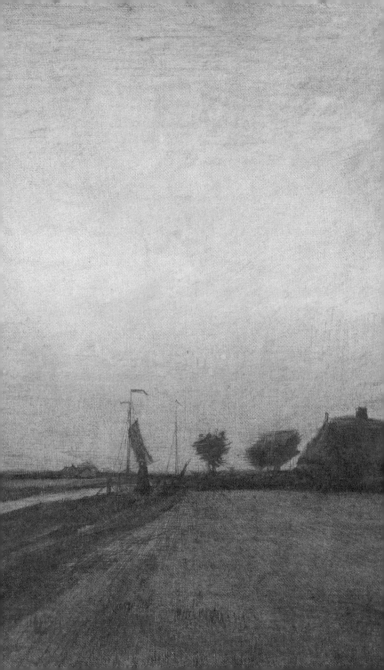

'I've also started pen drawings again, specifically with a view to painting, because one can go into such details with the pen as painted studies cannot do, and one does well to make two studies, one entirely drawn for the way things are put together, and one painted for the colour. If this can be done, that is, and the occasion permits, this is a way of working up the painted study later.'

CREATIVE INSPIRATION
VAN GOGH

ON NATURE

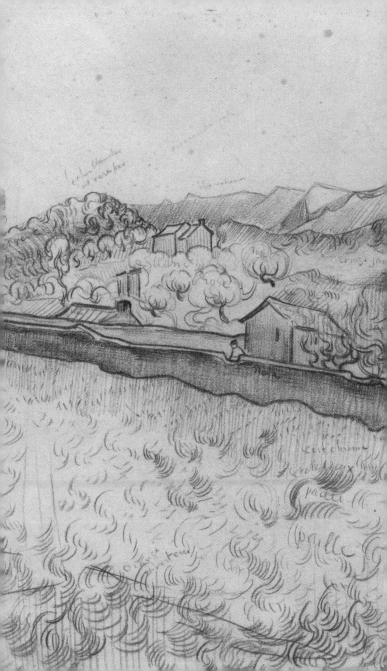

'Many landscape painters don't have that intimate knowledge of nature possessed by those who have looked at the fields with feeling from childhood. Many landscape painters give something that satisfies neither you nor me, for example, as people (even if we appreciate them as artists) …'

'You will say, but everyone has surely seen landscapes and figures from childhood. Question: was everyone also thoughtful as a child? Question: did everyone who saw them – heath, grassland, fields, woods – also love them, and the snow and the rain and the storm?'

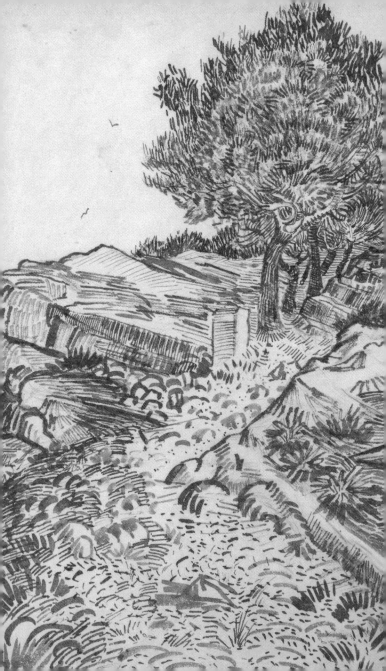

'. . . to enjoy such a thing is like coitus,
the moment of the infinite.'

'So if you want to do as artists do, gaze upon the white and red poppies with the bluish leaves, with those buds raising themselves up on stems with gracious curves.'

CREATIVE INSPIRATION
VAN GOGH

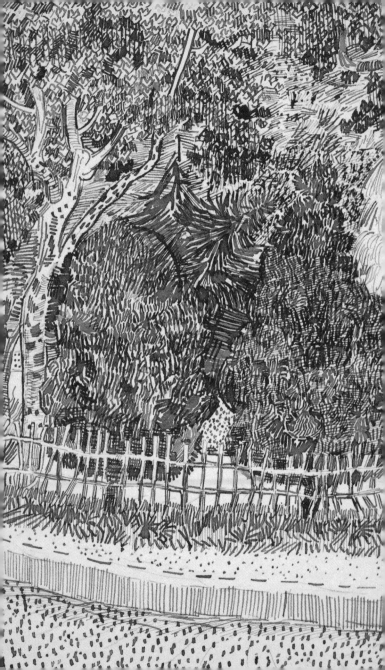

'If one truly loves nature one finds beauty
everywhere.'

CREATIVE INSPIRATION
VAN GOGH

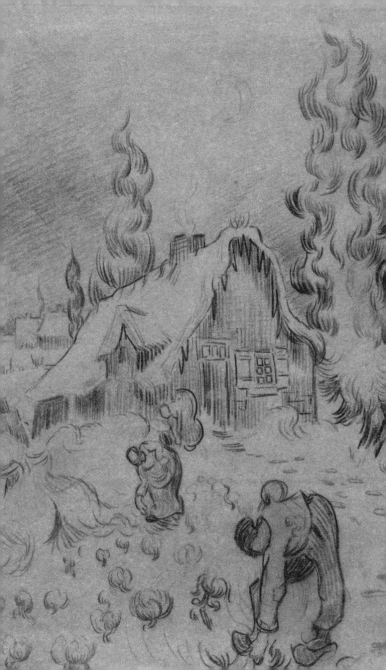

'What I think is the best life, oh without even the slightest shadow of a doubt, is a life made up of long years of being in touch with nature out of doors – and with the something on high – unfathomable, "awfully Unnameable", because one can't find a name for it – above that nature.'

/

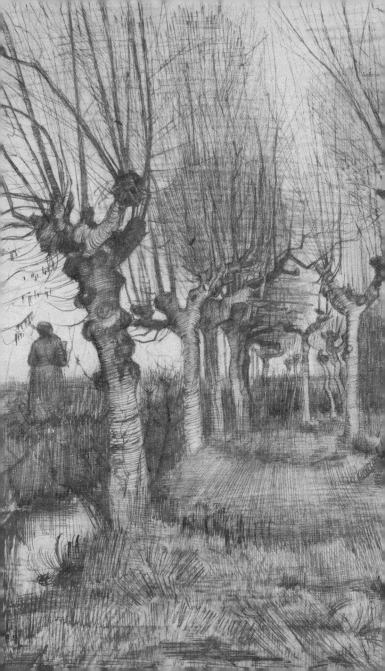

'... in all of nature, in trees for instance,
I see expression and a soul, as it were.
A row of pollard willows sometimes
resembles a procession of orphan men.

'Young corn can have something ineffably
pure and gentle about it that evokes an
emotion like that aroused by the expression
of a sleeping child, for example.

'The grass trodden down at the side of
a road looks tired and dusty like the
inhabitants of a poor quarter. After it had
snowed recently I saw a group of Savoy
cabbages that were freezing, and that
reminded me of a group of women I had
seen early in the morning at a water and fire
cellar in their thin skirts and old shawls.'

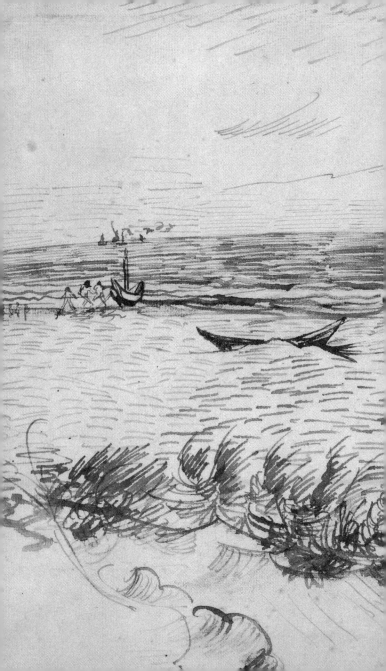

'The sea, which I love very dearly, needs to be attacked with painting, otherwise one has no grip on it.'

CREATIVE INSPIRATION
VAN GOGH

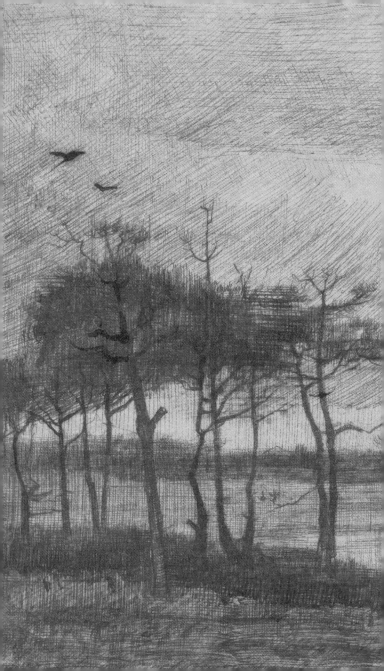

'Rarely of late has the stillness, nature alone, so appealed to me. Sometimes it's precisely those spots where one no longer feels anything of what's known as the civilized world and has definitely left all that behind – sometimes it's precisely those spots that one needs to achieve calm.'

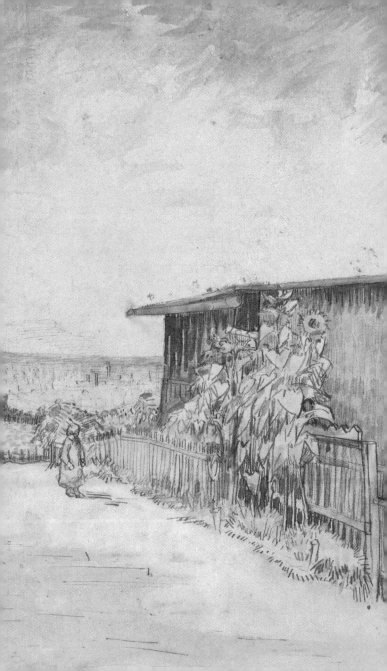

'... the heath is sometimes far from pleasant in the heat of midday. It's as irritatingly tedious and fatiguing as the desert, just as inhospitable, and as it were hostile. Painting it in that blazing light and capturing the planes vanishing into infinity is something that makes one dizzy. So one mustn't think that it has to be conceived sentimentally; on the contrary it's almost never that.'

CREATIVE INSPIRATION
VAN GOGH

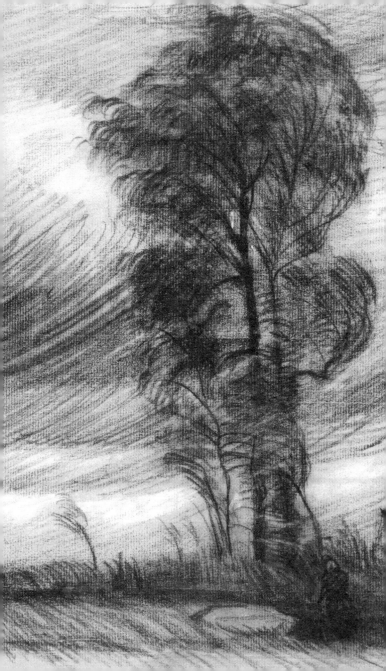

'We have, by turns, beautiful, clear autumn days here and stormy ditto. Actually I find the latter the most beautiful, even though they make it more awkward to work outdoors, even though it's sometimes completely impossible to do so. All the same, going out and reworking a study one has made on a fine day in accordance with what one sees outdoors in the rain can be done, and it satisfies me.'

CREATIVE INSPIRATION
VAN GOGH

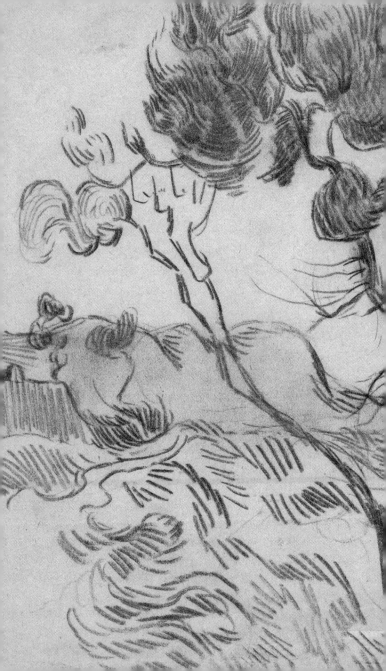

'… nature like this can sometimes awaken in a mind things that would otherwise never have woken.'

ON HUMANITY

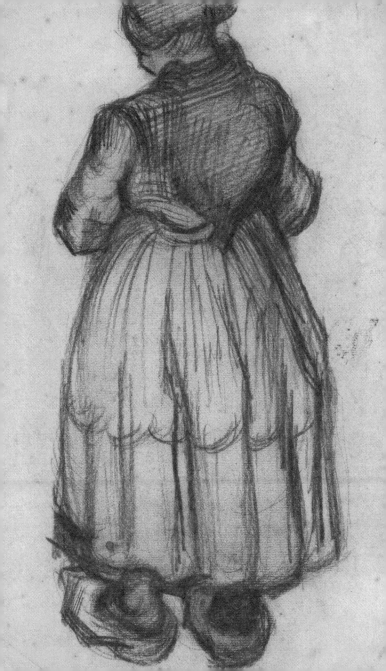

'I feel that my work lies in the heart of the people, that I must keep close to the ground, that I must delve deeply into life and must get ahead by coping with great cares and difficulties.'

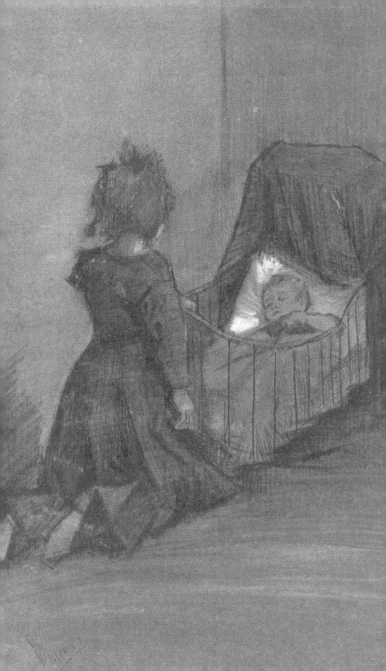

'How much good it does a person if one
is in a gloomy mood to walk on the empty
beach and look into the grey-green sea
with the long white lines of the waves.
Yet if one has a need for something great,
something infinite, something in which
one can see God, one needn't look far.
I thought I saw something – deeper, more
infinite, more eternal than an ocean – in
the expression in the eyes of a baby –
when it wakes in the morning and crows –
or laughs because it sees the sun shine into
its cradle. If there is a "ray from on high",
it might be found there.'

CREATIVE INSPIRATION
VAN GOGH

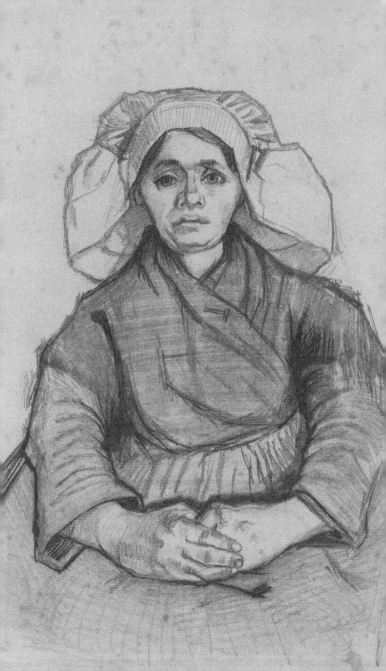

'… I'd rather paint people's eyes than cathedrals, for there's something in the eyes that isn't in the cathedral – although it's solemn and although it's impressive – to my mind the soul of a person … is more interesting.'

CREATIVE INSPIRATION
VAN GOGH

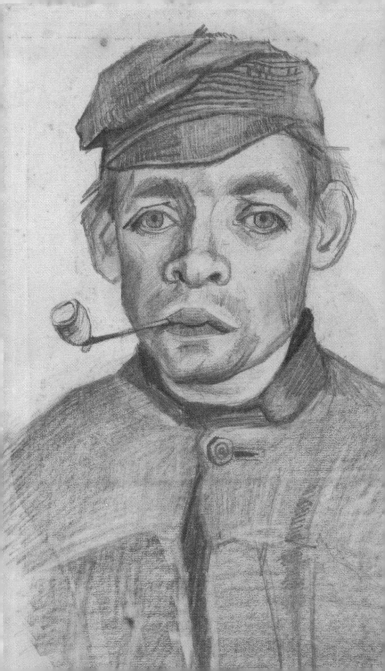

'I've done the portrait of Mr Gachet with an expression of melancholy which might often appear to be a grimace to those looking at the canvas. And yet that's what should be painted, because then one can realize, compared to the calm ancient portraits, how much expression there is in our present-day heads, and passion and something like waiting and a shout. Sad but gentle but clear and intelligent …'

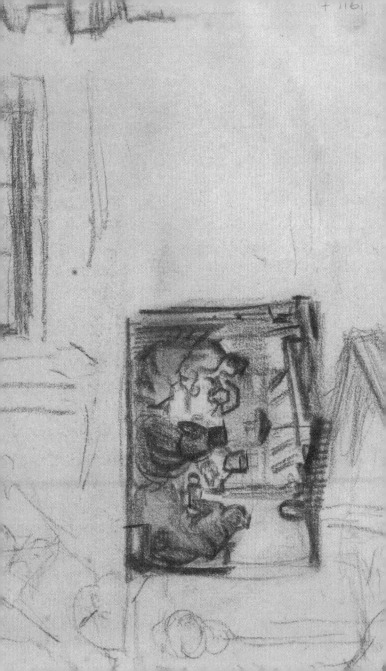

'You see, I really have wanted to make it so that people get the idea that these folk, who are eating their potatoes by the light of their little lamp, have tilled the earth themselves with these hands they are putting in the dish, and so it speaks of MANUAL LABOUR and – that they have thus honestly earned their food. I wanted it to give the idea of a wholly different way of life from ours – civilized people. So I certainly don't want everyone just to admire it or approve of it without knowing why.'

DOUBT

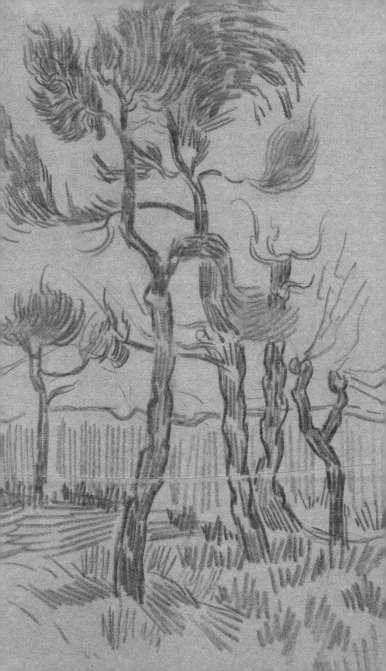

'Money leaves us cold except as far as it's
needed for the absolute essentials of life.'

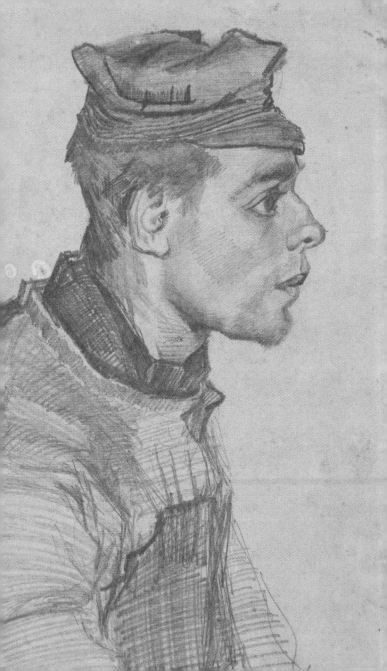

'Don't take things that don't concern you directly too much to heart, and don't let them weigh upon you *too* heavily.'

CREATIVE INSPIRATION
VAN GOGH

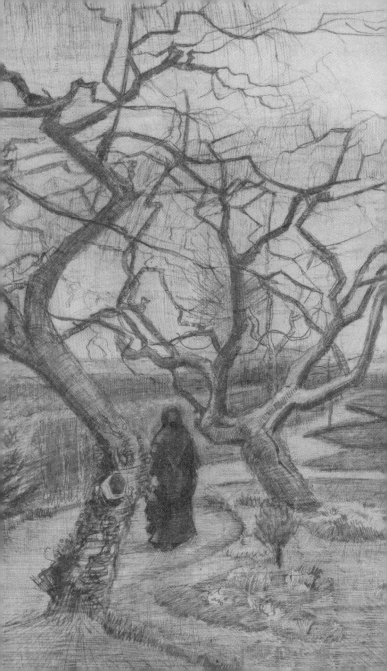

'We sometimes feel rather lonely and
long for friends, and think we'd be
quite different and happier if only we
found "it", a friend of whom we would
say, "this is it". But you, too, will already
have started to notice that there's a lot of
self-deception behind this, and that this
longing, if we were to surrender to it
too much, would cause us to stray from
the path.'

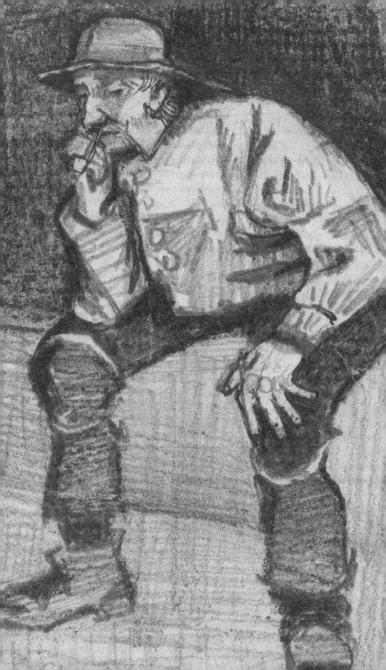

'As against what I wrote to you, that I'm often heavy-hearted about many things, can't see everything as progress, &c., there's what I also said on a previous occasion: there are things that are worth doing one's best for, either because they gain approval or because, just the opposite, they have their own *raison d'être. Blessed is he who has found his work*, says Carlyle, and that's absolutely true.'

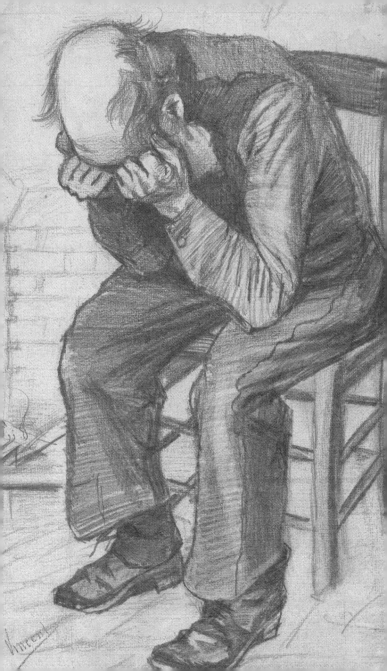

'Do you know what I couldn't help thinking? – that in the first part of life as a painter one sometimes unintentionally makes things difficult for oneself – through a feeling of not yet having mastered the business – through the uncertainty one feels about whether one will master it – through the fierce desire to make progress – through not yet trusting oneself – one *cannot* put aside a certain feeling of being harried, and one harries oneself despite not wanting to be harried when one works. There's nothing to be done about it, and this is a time that one also can't do without, and that should not and cannot be otherwise, in my view.'

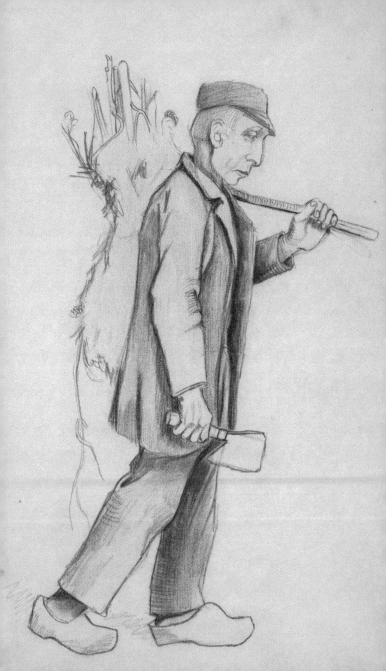

'The difficulties one faces in the first phase
give the studies a painful quality at times.

'I don't regard this as something that
discourages me, though, because I've
noticed it in others as much as in myself,
and in them it has increasingly gone away
of its own accord.

'And work remains *difficult* at times
throughout one's life, I believe,
but not always with so few results as
in the beginning.'

CREATIVE INSPIRATION
VAN GOGH

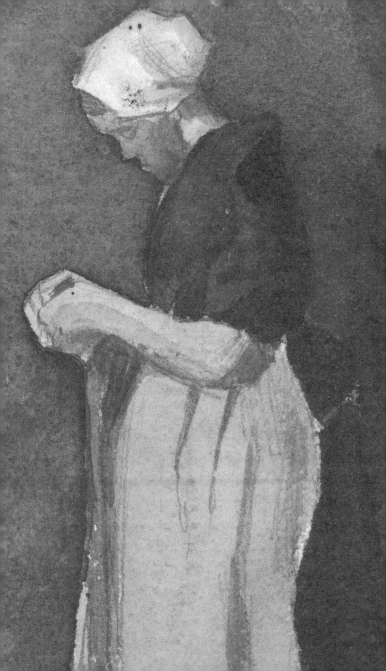

'If something in you yourself says "you aren't a painter" – IT'S THEN THAT YOU SHOULD PAINT ...'

CREATIVE INSPIRATION
VAN GOGH

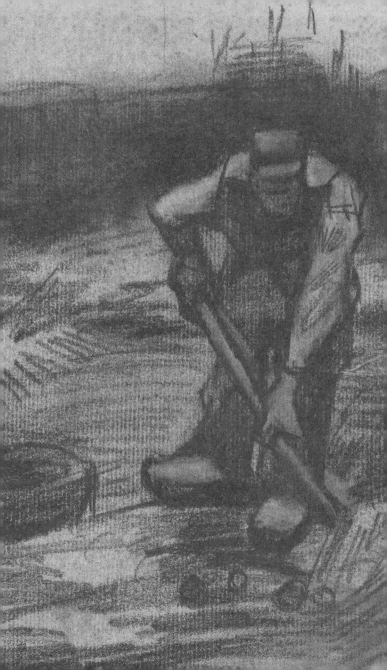

'While I'm working I feel an unlimited confidence in art and that I'll succeed, but on days of physical exhaustion or when there are financial obstacles I feel that faith less and am overcome by doubt, which I try to get over by immediately setting to work.'

CREATIVE INSPIRATION
VAN GOGH

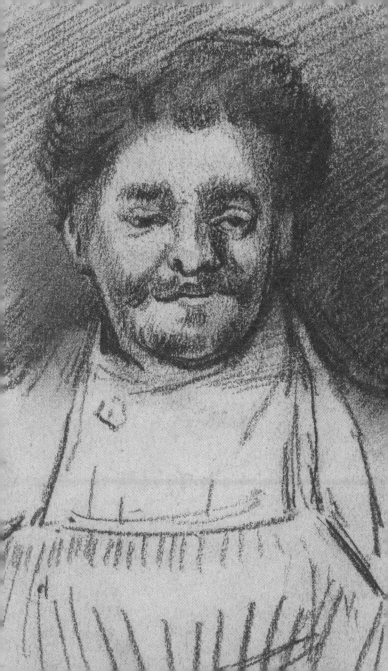

'Dear brother, don't think of me as being anything other than an ordinary painter facing ordinary problems, and don't imagine there's anything unusual when there are hard times. I mean, don't picture the future either black or brightly lit; you'll do better to go on believing in grey.'

CREATIVE INSPIRATION
VAN GOGH

SIGNS OF
PROGRESS

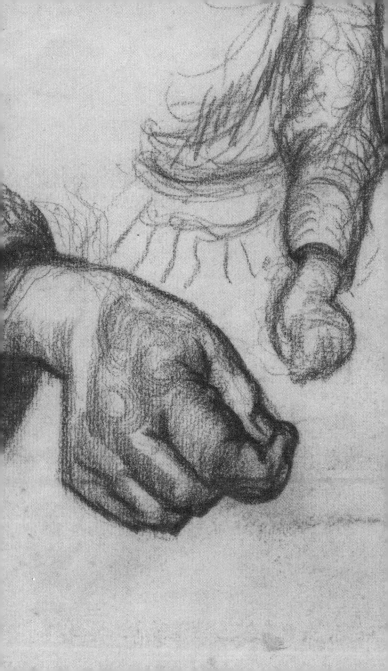

'But what's your ultimate goal, you'll say. That goal will become clearer, will take shape slowly and surely, as the croquis becomes a sketch and the sketch a painting, as one works more seriously, as one digs deeper into the originally vague idea, the first fugitive, passing thought, unless it becomes firm.'

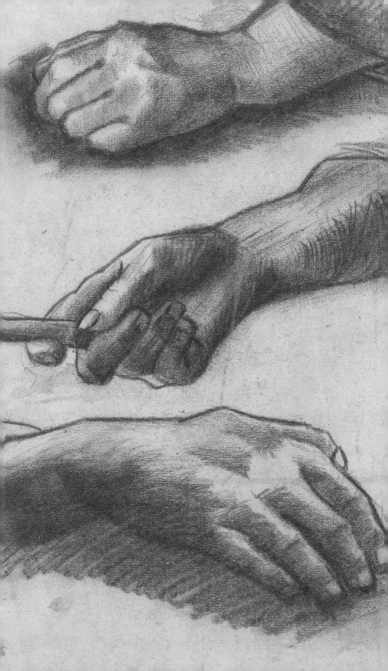

'If you drew just one thing as it should
be drawn, the desire to attack 1,000 other
things would be irresistible. But the most
difficult part is taking that first step.'

CREATIVE INSPIRATION
VAN GOGH

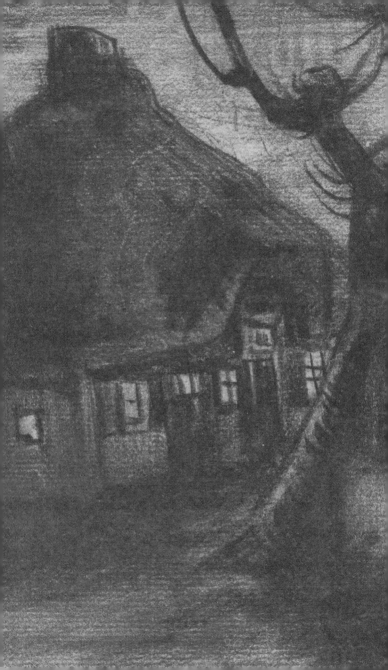

'But the way to do it better later is to do it as well as one can today, there can't be anything but progress tomorrow.'

CREATIVE INSPIRATION
VAN GOGH

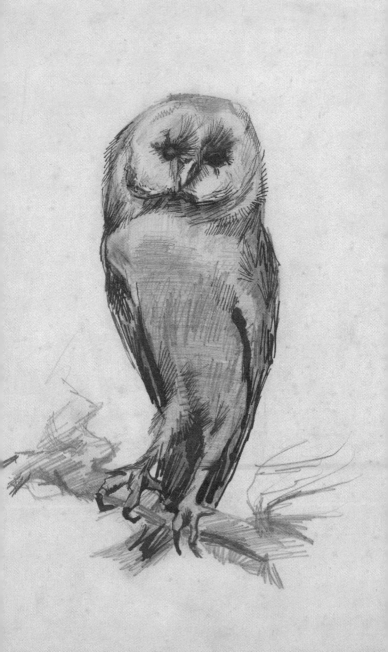

'I feel a power in me that I must develop,
a fire that I may not put out but must fan,
although I don't know to what outcome it
will lead me …'

CREATIVE INSPIRATION
VAN GOGH

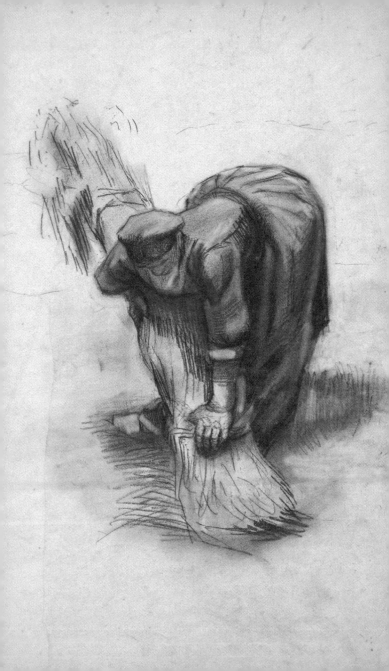

'A few years ago I went walking with Rappard outside Brussels at a spot they call the Vallée de Josaphat ... There was a sandpit there where diggers were at work – there were women looking for dandelion leaves, a peasant was sowing – we looked at all this and at the time I was half despairing: will I ever succeed in making what I consider so beautiful? Now I'm no longer so despairing, now I can capture those peasants and women better than then, and through carrying on working patiently I can arrive at what I wanted, in a sense.'

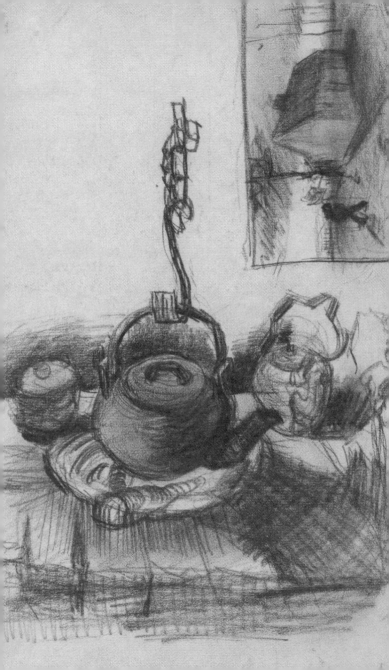

'As long as there's bread in the house
and I have a little in my pocket to pay
for models, what more could I want? My
enjoyment lies in my work getting better –
and that absorbs me more and more.'

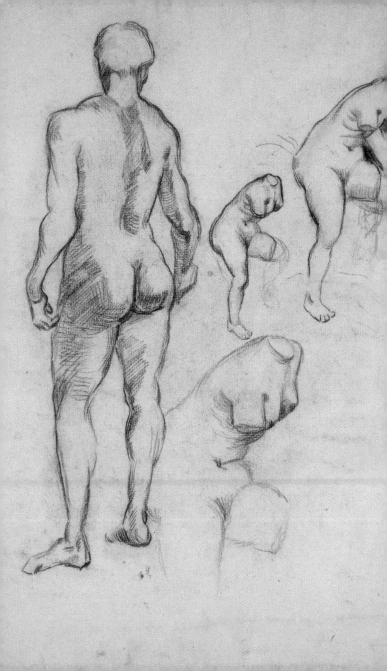

'Last year I repeatedly tried to paint figure studies. Well, I was driven to desperation by the way they turned out. Now I've started again and I no longer have anything directly hindering me in the execution, because I draw much more easily than last year.'

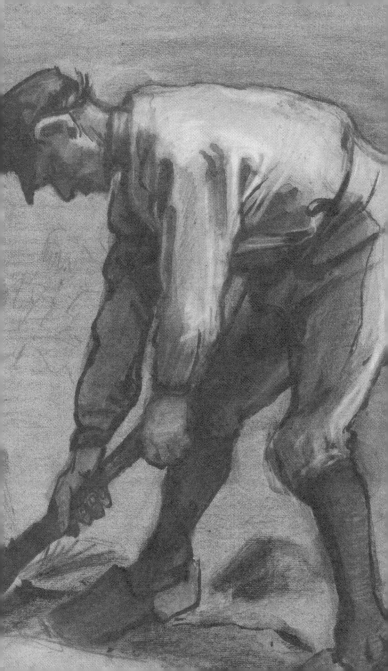

'What has given me a degree of encouragement of late is that, although I haven't painted for several months, I believe there's progress nonetheless in the painted studies done last year and now. This is because things like drawing and measuring proportions, with which I had a lot of trouble then, now fall into place more or less, and so as I sit before nature I need only think about painting, instead of thinking about two things at once, as it were, drawing and painting.'

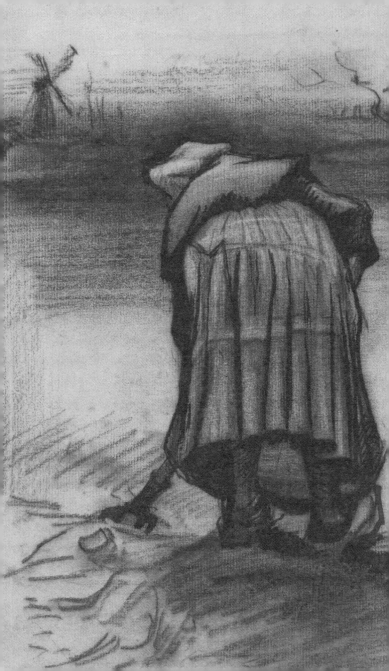

'… studies that fail in some respects turn out one day to have a purpose and to be of use for some new composition after all.'

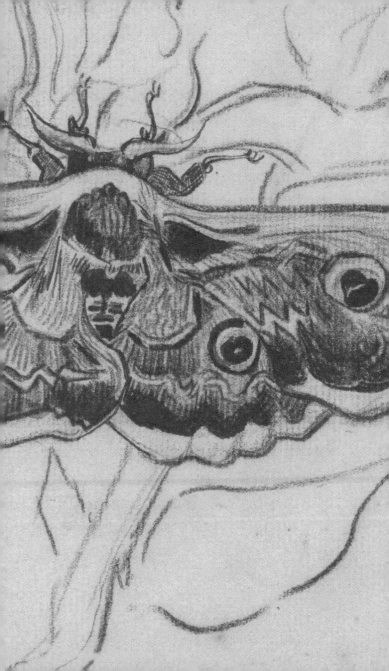

'For the great doesn't happen through impulse alone, and is a succession of little things that are brought together.'

CREATIVE INSPIRATION
VAN GOGH

COMMUNITY

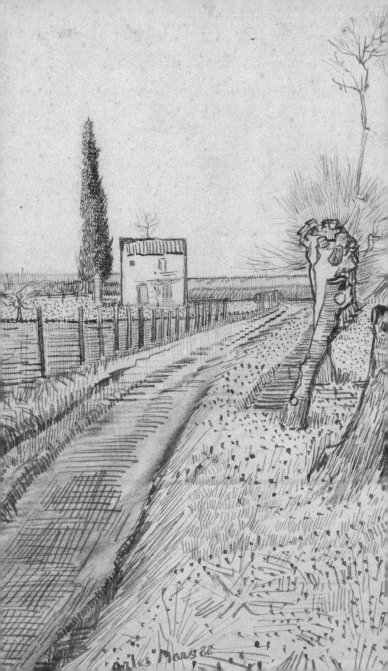

'And what I believe does a great deal of good is if one doesn't work absolutely alone, because the work inevitably absorbs one, but one doesn't become lost in that absorption because each advises the other, can keep the other on the right path.'

CREATIVE INSPIRATION
VAN GOGH

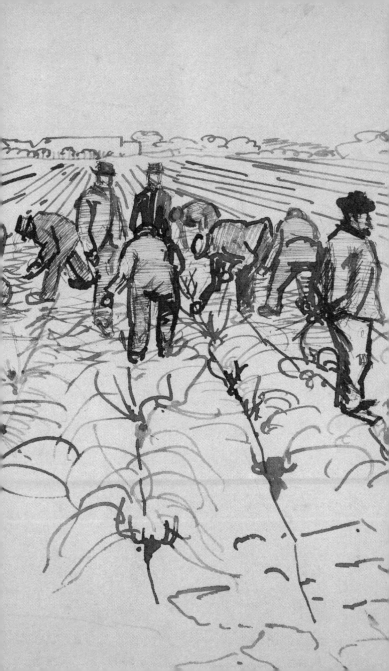

'People strengthen each other when they work together, and an entity is formed without personality having to be blotted out by the collaboration.'

CREATIVE INSPIRATION
VAN GOGH

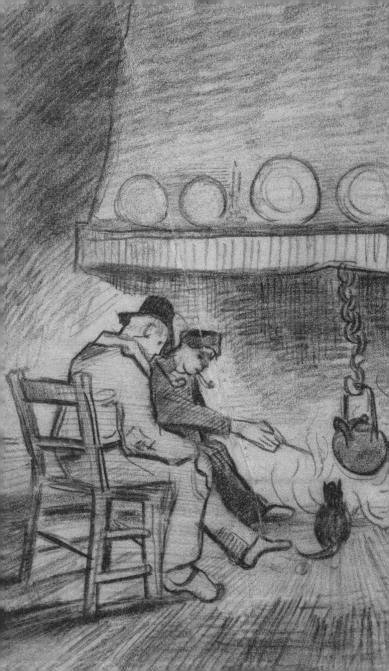

'Of course I must seek in order to find, and not everything will come off by a long way, but in the end the work will be good.

'Patience until it's good, not letting go until it's good, not doubting, is what I would like you and I to have together and to hold on to. If we hold onto that, I don't know to *what extent* we'll benefit financially, but I do believe that – *on condition of collaboration and solidarity, however* – we'll be able to persevere for our whole lives, sometimes selling nothing and finding life hard, then at times selling and having it easier.'

CREATIVE INSPIRATION
VAN GOGH

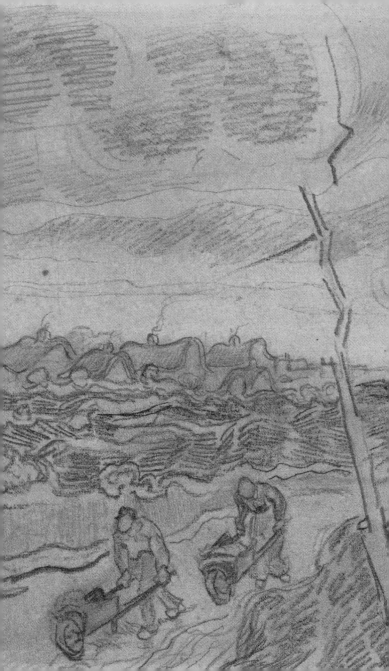

'Persevering depends on our will to stay together. As long as that will exists, it is possible.'

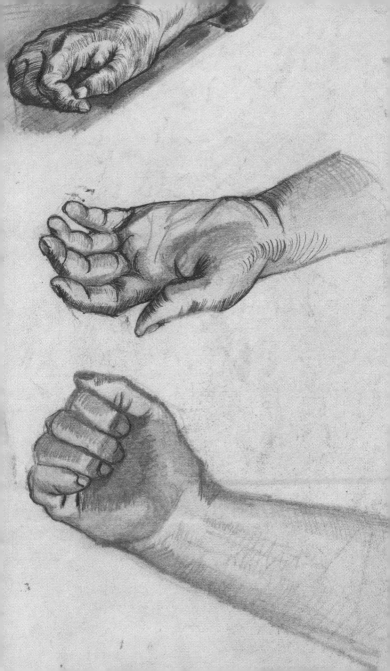

'It's really terrible that one sometimes has to search for a year for something that could be explained in a fortnight by someone who is further along. It comes down to personal effort, but the road is easier or harder depending on whether one is alone or not.'

CREATIVE INSPIRATION
VAN GOGH

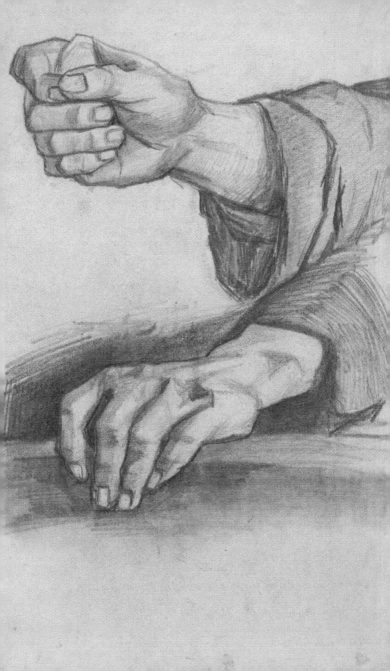

'Not *all* painters make a lot of studies
– but many do, and the young ones
in particular have to do it as much as
possible, don't they? Anyone who owns a
painter's studies can be as good as certain
(at least so it seems to me) that there's a
bond between the painter and him that
can't easily be broken just on a whim.'

INSPIRATION

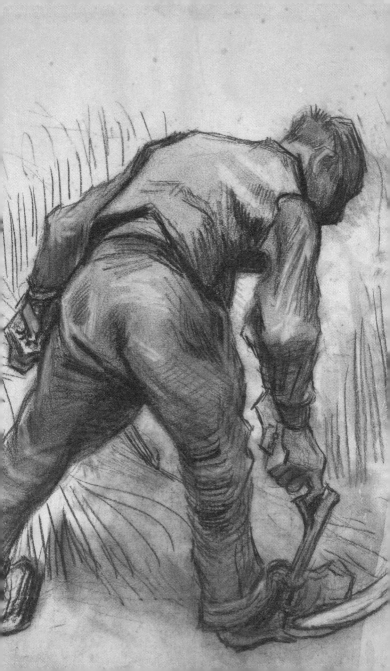

'… *find things beautiful* as much as you can, most people *find too little beautiful*.'

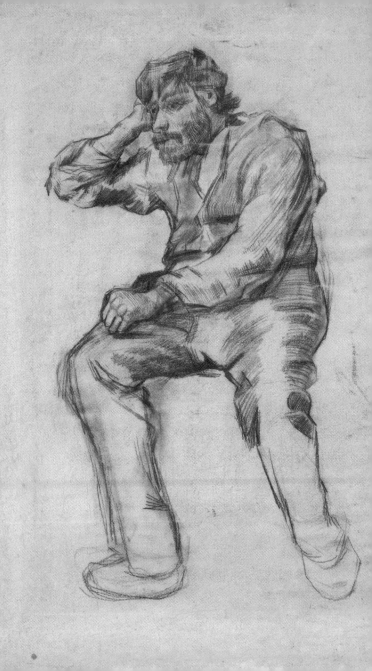

'I know for certain that something would awaken in you in your own studio which you don't know of now – a huge, hidden force of working and creating.

'And once it's awake, it's awake for good.'

CREATIVE INSPIRATION
VAN GOGH

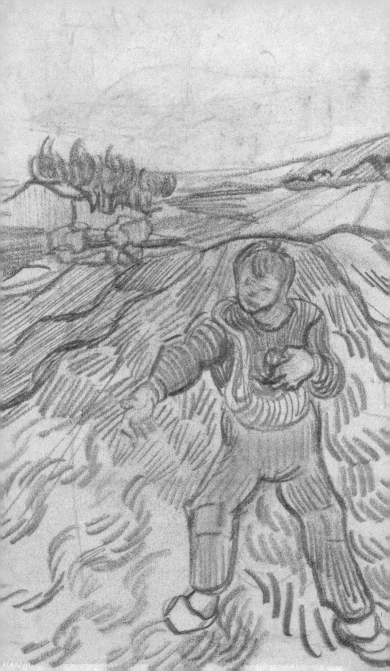

'Life is the same as drawing: sometimes one has to act quickly and resolutely, tackle things with willpower, take care that the broad outlines appear with lightning speed. It's no use hesitating or doubting, and the hand may not tremble and the eye may not wander but must remain fixed on one's purpose ... While *doing* it there's little space for reflecting or reasoning. And acting quickly is a man's work and before one is capable of it one must have experienced something. Sometimes a helmsman succeeds in making use of a gale to make headway instead of foundering because of it.'

CREATIVE INSPIRATION
VAN GOGH

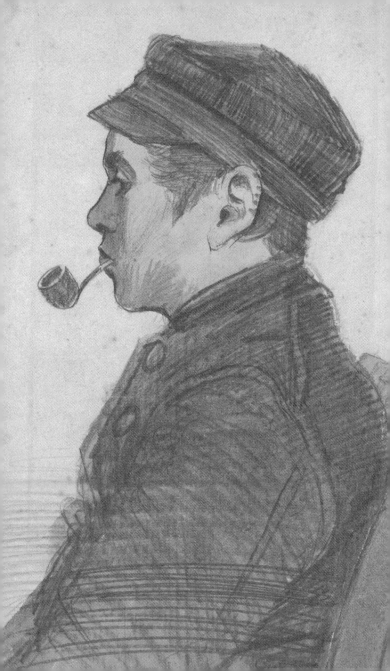

'I believe so strongly in your artistic ability that to me you'll be an artist as soon as you pick up a brush or a piece of chalk and, clumsily or not clumsily, make something.'

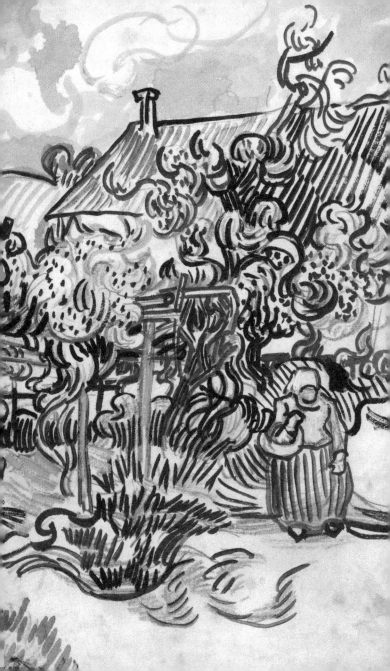

'In that case, I see nothing reckless, nothing impractical, nothing foolish in that you and I should just feel our energy, ourselves, that our love for art might inspire in us a collier's faith to say what others have said before and will say again after us. Namely that even if the situation is ominous, and even if we're very poor &c. &c., *yet we firmly concentrate on one single thing, on painting, naturally.*'

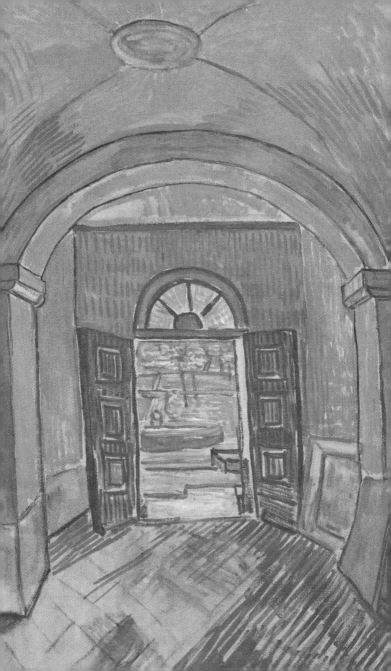

'To understand all is to forgive all, and I believe that *if* we knew everything we'd arrive at a certain serenity. Now having this serenity as much as possible, even when one knows – little – nothing – for certain, is perhaps a better remedy against all ills than what's sold in the chemist's. *A lot comes of its own accord, one grows and develops of one's own accord.*'

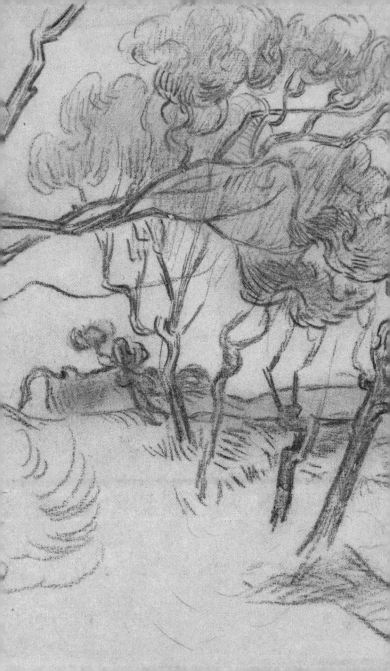

'Enjoy yourself too much rather than
too little, and don't take art or love too
seriously either ...'

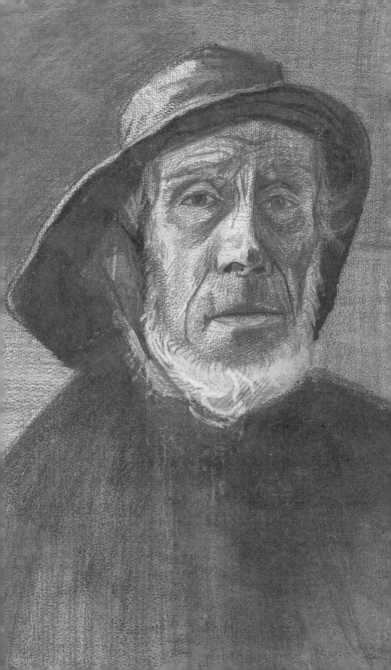

'Almost no one knows that the secret of beautiful work is to a large extent good faith and sincere feeling.'

CREATIVE INSPIRATION
VAN GOGH

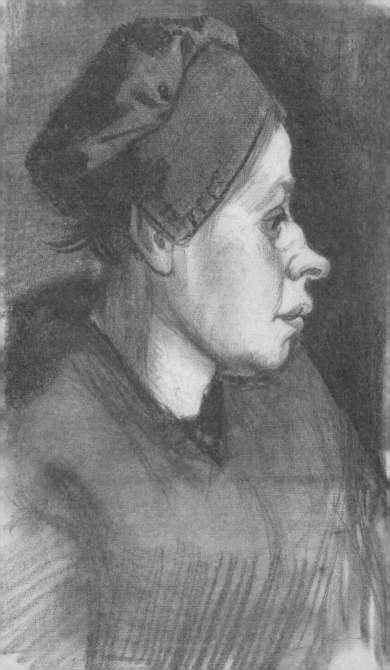

'I sometimes find it difficult to believe that a period of only 50 years, say, is enough to bring about a total change that turns *everything* around. Yet precisely through reflecting on history sometimes, one sees these relatively rapid and continuous changes. And for my part I'm led by this to the conclusion that every person still always puts some weight in the scale, though it may not be much, and that how one thinks and acts isn't a matter of indifference. The battle is short and it's worthwhile being sincere.'

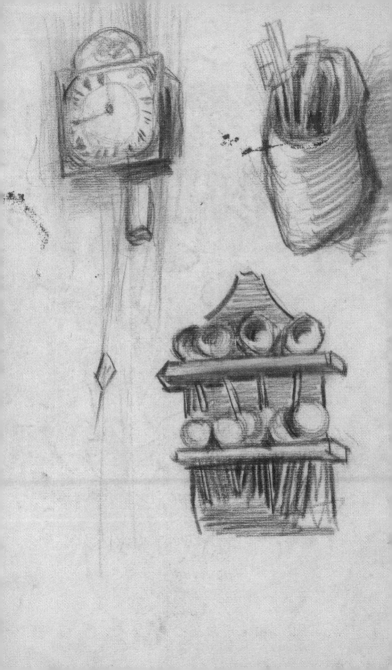

'Let's make the most of the time, because wasting time is the most expensive thing of all.'

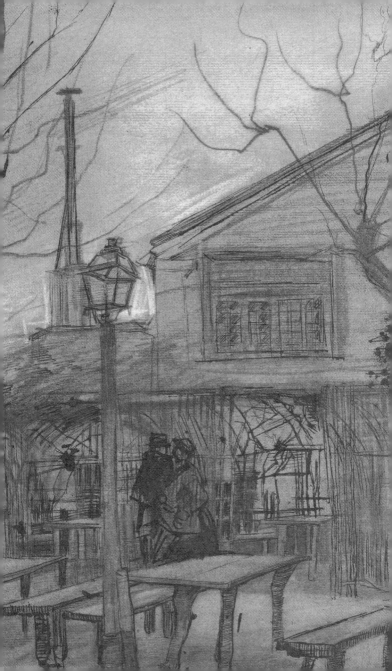

'We must treat the world with so much good heart, so much energy, so much coolness, not taking things too hard ...'

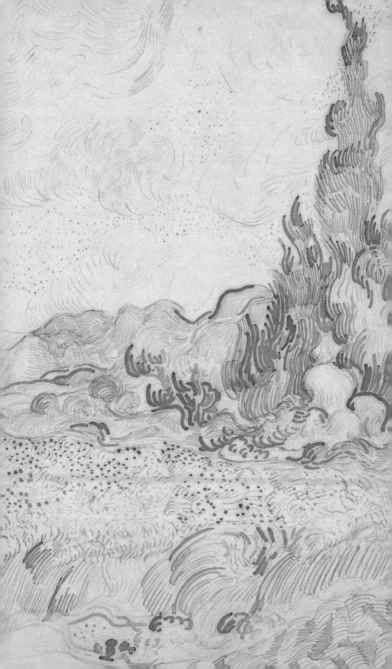

'A person who doesn't feel small – who doesn't realize that he's a speck – what a fundamental mistake he makes.'

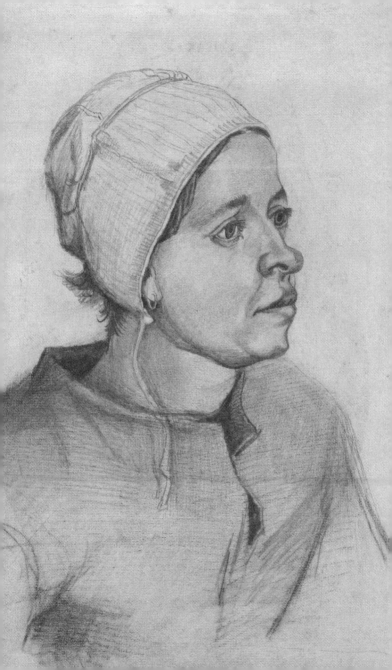

'And love is something eternal, it changes its aspect but not its foundation. And there's the same difference between someone who loves and the same man before as between a lamp that is lit and one that isn't.'

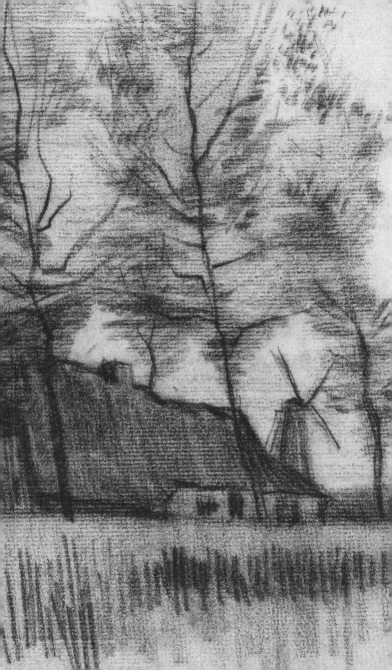

'Come on, old chap, come and paint with me on the heath, in the potato field, come and walk with me behind the plough and the shepherd – come and stare into the fire with me – just let the storm that blows across the heath blow through you. Break out. I don't know the future, how it could be different or not, whether everything will go well for us. But all the same I can't speak otherwise. Don't look for it in Paris, don't look for it in America, it's all the same, always exactly the same. Change indeed, look for it on the heath.'

Credits

Text: *Vincent van Gogh: The Letters*, Leo Jansen, Hans Luijten and Nienke Bakker, eds, Amsterdam, 2009. The letters are translated from Dutch and French to English by the Van Gogh Letters Project, www. vangoghletters.org. Images: Van Gogh Museum, Amsterdam (Vincent van Gogh Foundation).

6 'Marguerite Gachet at the Piano', image no. d427V • *Why Create?* 10 'Standing Man Seen from the Back', image no. d157V • 11 let224 • 12 'Sower in the rain', image no. d338V • 13 let152 • 14 'Stairs in the garden of the asylum', image no. d438V • 15 let214 • 16 'Melancholy', image no. d87V • 17 let574 • 18 'Woman with a child on her lap', image no. d71V • 19 let398 • 20 'View of Montmartre', image no. d131V • 21 let585 • 22 'Seated Girl Seen from the Front', image no. d430V • 23 let682 • *Daily Work* 26 'Studies of diggers', image no. d434V • 27 let115 • 28 'Man winding yarn', image no. d387V • 29 let290 • 30 'Old man with a top hat', image no. d183V • 31 let297 • 32 'Three men shouldering spades on a road in the rain', image no. d240V • 33 let305 • 34 'Soup distribution in a public soup kitchen', image no. d783V • 35 let376 • 36 'A Man and a Woman Seen from the Back', image no. d135V • 37 let560 • 38 Tracing of 'The plum tree teahouse at Kameido' of Hiroshige, image no. d772V • 39 let274 • 40 'Woman with a fork in a winter landscape', image no. d283V • 41 let631 • *Process* 44 'Tree and bushes in the garden of the asylum', image no. d334V • 45 let397 • 46 'Landscape with a stack of peat and farmhouses', image no. d386M • 47 let057 • 48 'Studies of a hand', image no. d246V • 49 let254 • 50 'The sower (after Millet)', image no. d443V • 51 let166 • 52 'Tassel hyacinth', image no. d425V • 53 let574 • 54 'Three cicadas', image no. d145V • 55 let290 • 56 'Reaper', image no. d363V • 57 let291 • 58 'Avenue of poplars', image no. d11V • 59 let464 • 60 'Torso of Venus', image no. d136V • 61 let310 • 62 'Seated woman', image no. d397V • 63 let370 • 64 'Entrance to the Moulin de la Galette', image no. d148V • 65 let387 • 66 'Landscape in Drenthe', image no. d810M • 67 let388 • *On Nature* 70 'Mountain landscape behind the walled wheatfield', image no. d250V • 71 let291 • 72 'The rock of Montmajour with pine trees', image no. d344V • 73 let649 • 74 'Wild vegetation', image no. d177V • 75 let785 • 76 'Park with fence', image no. d346V • 77 let022 • 78 'Landscape with Cypresses', image no. d197V • 79 let403 • 80 'Pollard birches', image no. d364V • 81 let292 • 82 'Figures on the beach', image no. d199V • 83 let363 • 84 'Pine trees in the fen', image no. d105V • 85 let370 • 86 'Shed with sunflowers', image no. d352V • 87 let387 • 88 'Landscape in stormy weather', image no. d54V • 89 let399 • 90 'Landscape with pine trees', image no. d261V • 91 let401 • *On Humanity* 94 'Woman with a shawl', image no. d103V • 95 let226 • 96 'Girl kneeling by a cradle', image no. d72V • 97 let292 • 98 'Seated woman', image no. d429V • 99 let549 • 100 'Head of a young man with a pipe', image no. d89V • 101 let886 • 102 'Studies of the interior of a cottage, and a sketch of The potato eaters', image no. d389V • 103 let497 • *Doubt* 106 'Pine trees and wall in the garden of the asylum', image no. d257V • 107 let400 • 108 'Head of young man', image no. d424V • 109 let052 • 110 'Winter garden', image no. d365V • 111 let067 • 112 'Fisherman with Sou'wester', image no. d323V • 113 let294 • 114 'Worn out', image no. d378V • 115 let310 • 116 'Man with a sack of wood', image no. d383M • 117 let310 • 118 'Scheveningen woman', image no. d276V • 119 let400 • 120 'Peasant lifting potatoes', image no. d121V • 121 let368 • 122 'Head of a Man', image no. d40V • 123 let375 • *Signs of Progress* 126 'Two hands & Two Arms', image no. d392V • 127 let155 • 128 'Three hands', image no. d100V • 129 let214 • 130 'Two studies of a cottage', image no. d90V • 131 let215 • 132 'Barn Owl Viewed from the Side', image no. d152V • 133 let292 • 134 'Peasant woman binding sheaves', image no. d178V • 135 let293 • 136 'Kettle over a fire, and a cottage by night', image no. d78V • 137 let297 • 138 'Standing Female Nude Seen from the Back', image no. d160V • 139 let370 • 140 'Man breaking up the soil', image no. d119V • 141 let370 • 142 'Peasant woman lifting potatoes', image no. d108V • 143 let330 • 144 'Giant peacock moth', image no. d185V • 145 let274 • *Community* 148 'Jardin du Luxembourg', image no. d127V • 149 let403 • 150 'Figures in a field', image no. d415V • 151 let305 • 152 'Figures by the fireplace', image no. d189V • 153 let377 • 154 'Landscape with figures pushing wheelbarrows', image no. d188V • 155 let377 • 156 'Three hands', image no. d98V • 157 let393 • 158 'Two hands', image no. d97V • 159 let492 • *Inspiration* 162 'Reaper (F1317)', image no. d172V • 163 let017 • 164 'L' Ecorché and Borghese Gladiator', image no. d400V • 165 let215 • 166 'Field with sower', image no. d186V • 167 let226 • 168 'Young man with a pipe', image no. d3V • 169 let403 • 170 'Old vineyard with peasant woman', image no. d446V • 171 let404 • 172 'Vestibule in the asylum', image no. d176V • 173 let574 • 174 'Road with trees', image no. d258V • 175 let574 • 176 'Head of a fisherman with a fringe of beard and a sou'wester', image no. d70V • 177 let291 • 178 'Head of a woman', image no. d92V • 179 let312 • 180 'Clock, clog with cutlery and a spoon-rack', image no. d394V • 181 let391 • 182 'A Guinguette', image no. d351V • 183 let397 • 184 'Wheatfield and cypresses', image no. d445V • 185 let400 • 186 'Head of a woman', image no. d395V • 187 let330 • 188 'Landscape with cottages and a mill', image no. d53V • 189 let396 • 192 'Country Road', image no. d428V.

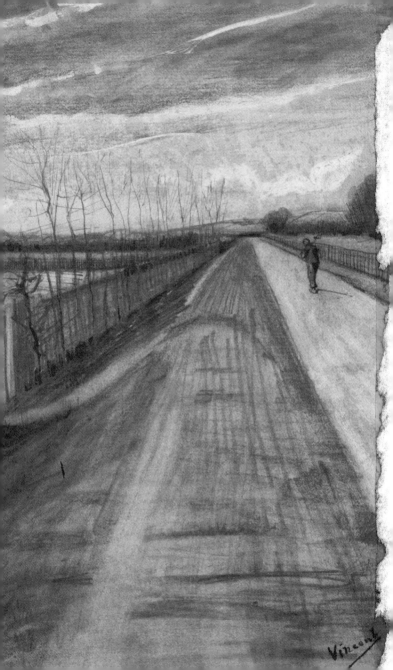